AN EYEWITNESS ACCOUNT OF
GALLIPOLI

TO THE HONOUR AND GLORY OF MY COMRADES,
WITH WHOM I SPENT THOSE FIRST TERRIBLE WEEKS AT ANZAC
I DEDICATE THIS WORK.

AN EYEWITNESS ACCOUNT OF
GALLIPOLI

WORDS AND SKETCHES BY SIGNALLER ELLIS SILAS

EDITED BY JOHN LAFFIN

ROSENBERG

Foreword. By General Sir Ian Hamilton.

As the man who first, seeking to save himself trouble, omitted the five full stops and brazenly coined the word "Anzac," I am glad to write a line or two in preface to sketches which may help to give currency to that token throughout the realms of glory. Though treating so largely of death, they are life-like; though grim, they do justice also to the gaiety and good humour which never deserted any of our troops in the trenches; though slight, they seem solid and serious enough to such of us as were there. Therefore it is that I wish for these outlines of heroes abiding fame, and hope that many an Australian or New Zealander now unborn will better realise by their aid what a splendid thing it was to have been alive and crusading at Gallipoli in the year of our Lord 1915.

April 29th, 1916.

Introduction. *By General Sir William Birdwood.*

It gives me much pleasure to be able to write a very short introduction to the book of drawings of Signaller Ellis Silas, though these will themselves, I hope, appeal fully to all who see them, as portraying incidents in the lives of some of our Australian and New Zealand soldiers on service.

The sketches were made by Signaller Silas during the time he spent with the Australian troops on the Gallipoli Peninsula, and they contain an excellent record of the life spent by those troops during the months they and their comrades at Cape Helles and Suvla were upholding the honour of the British Flag in that part of the world.

I heartily wish Signaller Silas all success with his book, and trust that, before the war is finished, his health will enable him to rejoin the troops, and that he will find opportunity of giving us yet further proofs of his ability as an artist, in showing us something of the life of the troops in other theatres of war.

May 1st, 1916.

IN this work I have not touched upon the big historical facts, but have endeavoured to portray War as the soldier sees it, shorn of all its pomp and circumstance; the War that means cold and hunger, heat and thirst, the ravages of fever; the War that brings a hail of lead that tears the flesh and rends the limb, and makes of men, heroes. It is these little incidents that must necessarily be lost in the larger issues at stake, but which, none the less, constitute War, and form a large factor in the successful termination of a great movement.

Egypt was an interesting part of our military career, and I do not feel that this work would be quite complete without the introduction of a few Cairene incidents. If, perhaps, the behaviour of some of the Boys was not all that a Sunday School teacher might desire — God! if one could have seen them on that famous April 25th, their little human weaknesses could easily be forgiven — I cannot but feel honoured at being able to call such men my comrades.

And if I have succeeded in giving to the world a truthful record of their heroism and fortitude, then my work has not been in vain.

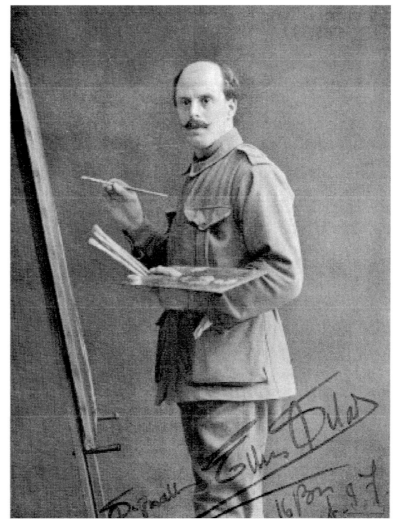

SIGNALLER ELLIS SILAS. [Photo by Bassano]

Ellis Silas — The Anzac Artist.

Private Ellis Silas of the 16th Battalion, Australian Imperial Force, is an important but little-known soldier: He was the only artist to paint and sketch actual battle scenes showing Australian soldiers in action at Gallipoli in 1915. Ellis knew war at first hand; he was in the thick of much action in April–May 1915 and it is astonishing that he survived.

Given his service as a soldier and his productivity as an artist it is remarkable that his name is not familiar to Australians while the names of Will Dyson and others are known to all students of Australia's part in the Great War and to many other people.

In writing this introduction to this new edition of Ellis Silas' book, first published early in 1916, I am conscious of the need to describe Silas' interesting background for those who have not heard of him.

Ellis Luciano Silas was born in London in 1885, the son of Louis Silas, a designer and professional painter of nature subjects and Letizia, an opera singer. Such parents could afford to have their son educated at home by tutors, after which he trained in his father's studio and studied under Walter Sickert, a noted artist.

Silas' chief interest at that time was in marine art and he joined the Royal Naval Volunteer Reserve more easily to study the sea. He set up his easel in a series of English coastal towns, including Brighton, where he produced seascapes and coastal subjects.

Emigrating to Australia in 1907, Silas lived briefly in Sydney, Melbourne and Adelaide before deciding that he liked Perth most of all and here he established a studio.

When war broke out in August 1914 Ellis at once wanted to join the AIF for service overseas but this was not easy.

Weighing only 134 pounds (61 kg), with a chest expansion of 34 inches, he was a slight figure and some medical examining officers rejected him. He persisted and a Captain V.O. Stacy accepted him on 28 September. Ellis took his enlistment oath to 'resist His Majesty's enemies' on 16 October.

He desperately wanted to join the Army Medical Corps, for which his nature made him eminently suitable, but he was sent to the Signallers Corps — as it was then known — and despatched to Blackboy Hill Camp, Western Australia. Some of his documents at this time show him as Silas Ellis; clerks and officers had difficulty in understanding that his surname was Silas, when it is usually a first name. On one form an impatient officer has heavily underscored SILAS to emphasise the family name.

Silas, though enthusiastic, was the odd man out among the tough West Australian bushmen who were his new mates in the 16th Battalion. His instructors despaired of him. On one

occasion, during parade ground drill, Ellis was fascinated by a beautiful sunset which held his attention. After a while he realised that the platoon had marched off, leaving him alone.

He wore his slouch hat in an odd way, apparently with the brim rolled up both sides. On parade, the adjutant shouted at him that he looked like a bloody bandit, though his language was stronger than this. In his diary, Silas wrote, "I thought I looked nice but individuality does not find favour in the army."

He was to prove himself a courageous and able soldier but his sensitive nature caused him profound distress at Anzac.

The 16th Battalion sailed to Melbourne for further training and the ship stopped in Adelaide, where the troops were given four hours leave. Most of the men made for the pubs, but Silas, despite having been seasick, went first to the art gallery and then visited his artist friends, James and William Ashton.

On 22 December the battalion boarded the troopship *Ceramic*, which stopped only long enough at Albany, Western Australia, to join a convoy. The ships reached Alexandria on 1 February 1915 and Silas' army-life sketches, paintings and drawings began from the time that his unit marched into camp at Heliopolis. The shades and tints intrigued him and he painted many watercolours. He had to join in the training and he became a competent signaller with semaphore flags but he remained much more interested in his art.

The 16th left for Lemnos Island on 11 April, in readiness for the Gallipoli campaign. The unit was not part of the first wave at dawn and Silas wrote, "In the distance I can just discern the Dardanelles opening up — the thunder of guns is much clearer. The weather this morning is beautiful; what will it be tonight?

"I wonder which of the men around me have been chosen by Death. I do not feel the least fear, only a sincere hope that I may not fail at the last moment."

With his mates he went ashore at Anzac Cove about 4pm and it was a "magnificent spectacle." He wrote of, "thousands of men rushing forward through this hail of death as though it were some big game. These chaps don't seem to know what fear means. In Cairo I was ashamed of them [because some were badly behaved] now I am proud of them, and feel a pygmy among them."

Silas was appalled at the carnage as he picked his way through the dead and the wounded. Amid great confusion, sixteen men struggled to hack out positions on Pope's Hill, an action which Silas sketched and painted. He spent all night running despatches up and down hill. With most of the signallers wounded or dead, Silas showed amazing fortitude and remained on duty for four days with nothing more than a few brief rests. He collapsed and was ordered out of the firing line.

On 2 May the 16th fought incessantly at Bloody Angle and only 307 survivors remained after 24 hours. "I don't think I will ever be able to forget this, it's horrible," Silas wrote. He was referring to "these fine stalwart men going up the gully

to reinforce and shortly returning, frightfully maimed and covered with blood."

Silas did not spare himself in doing his duty and he collapsed on the battlefield, from where he was rescued. The doctors found him to be suffering from extreme debility, shock and neurasthenia. By now devoted to his mates, Silas did not want to leave Anzac, but in May the battalion medical officer persuaded him to "spend a few weeks" away from Gallipoli. Almost certainly, the doctor knew that Silas was finished as a combat soldier.

With other sick and wounded he was taken to Egypt where he spent some time in the 1st Australian General Hospital at Heliopolis. From here he was sent to England for treatment at a hospital at Woodcote Park.

He was eventually discharged from the AIF, in London, on 17 August 1916, his papers marked "Permanently unfit for war service at home or abroad." He had served one year and 307 days and his military character was noted as "very good."

His signature on the discharge certificate and on other documents at this time is bold, artistic and confident, quite unlike his hesitant signature on the attestation paper of 1914.

His mind full of images of Anzac, Silas was anxious to commit them to canvas. The first work of his postwar career was the large oil, *Landing at Anzac* (244 x 152cm), which was accepted by the hanging committee of the Royal Academy in 1917. By now a patriotic Australian, Silas offered *Landing at Anzac* to Australia House, London. Sadly, the officials there refused it and what became of it is not known.

But Silas was to win recognition from a very special quarter. He had exhibited his work at a gallery in New Bond Street, the avenue of art galleries, and it received some publicity in the London press. Ellis Silas received a Royal Command: He was to bring his collection to Buckingham Palace and discuss it in private audience with King George V and Queen Mary.

This was a high honour for an unknown colonial artist, especially in private audience.

In June 1918 C.E.W. Bean interviewed Silas in London and suggested that he should paint the Anzacs digging in at Pope's Hill. The subsequent work he entitled *Digging in at Pope's Hill: End of a Great Day*. The Royal British Colonial Society of Artists included the work in an exhibition. This time Silas did not bother to approach Australia House.

His next work was probably his finest — *Roll Call*. He knew his subject from having attended such an after-battle roll call but he wanted it to be as realistic as possible so he asked AIF HQ officers in London to send him real Australian soldiers from among the many on leave or convalescent. Because he was well known to General Birdwood, he had no difficulty in getting these models. He wrote that "All the tragedy and grandeur of war [was] writ large upon their faces ... not Italian models or down at heel Englishmen dressed in Australian uniforms."

He later painted *Roll Call* in larger form and then in 1921 *Attack by 4th Australian Infantry Brigade at Bloody Angle, Anzac May 1915*.

Silas had always been interested in the South Seas and with the war over, he set off for these romantic parts of the world. He travelled to the Trobriand Islands, and there he produced his finest work; his delicate studies of native life were more highly acclaimed than his war paintings. In his book, *Primitive Arcadia*, he described how the native children would crowd around each morning to watch him brush his teeth, fascinated by this extraordinary performance.

On his return to London in 1925 Silas met Ethel Florence Detheridge, known as Daphne, and they were soon married, with Charles Robinson, another member of the famous London Sketch Club, as best man. Daphne was a devoted and adoring wife.

Silas was happy in his work at home, a splendid house in Brook Green, London, where he and Daphne entertained many people. He was endlessly productive, not only sketching and painting but designing murals, posters, souvenirs, menu cards and stained-glass windows. During World War II he worked for the nation, producing a fine collection of posters reflecting British life under wartime stress. One of his most profitable ventures were book illustrations and in 1972, at the age of 86, he was designing murals for new luxury liners. He died that year.

The British Museum acquired many of Silas' sketches of native life, also the collection of curios which he had brought back from Papua-New Guinea. He exhibited at the Royal Academy and all the great art centres in Britain and abroad. The Australian War Museum (it was not then the Australian War Memorial) bought *Digging in at Pope's Hill, Attack by the 4th Australian Infantry Brigade at Bloody Angle* and *Roll Call*. On a visit to Australia, Silas offered more works for sale but they were refused. Some critics and Australian painters commented adversely on his ability as an artist. In fact, they were envious of his success and some of them had long resented his private audience with the monarch when they had enjoyed no such privilege.

Silas spent less than a month at Anzac but this was longer than many of his comrades who had become casualties during the first few days. He had forced his frail frame to undertake prodigious labour and strain and in fortitude, courage and compassion for his mates he was a true Anzac.

How seriously he viewed Australia's campaign at Gallipoli is shown by the title he gave originally to this collection of sketches and word pictures — *Crusading at Anzac*. He had been worried that he might fail the test of battle; his officers and mates — and the official historian — knew that he had not failed.

Everything he sketched, he had seen personally. He was the Anzac artist.

John Laffin

The Indian Ocean.

IT was a sight, this huge fleet of transports, ploughing its way through a sapphire sea — a spectacle that, perhaps, will never be seen again. That this vast fleet was able to sail all those thousands of miles, without an escort of any kind, is an excellent proof of the splendid work the Navy has done.

Christmas Day, 1914.

Ellis Silas embarked at Melbourne on the troopship *Ceramic*, officially His Majesty's Australian Transport (HMAT) A40, on 22 December 1914. From ports around Australia the ships travelled singly and unprotected to Albany, Western Australia, where they were formed into convoys. Few of the men knew anything about world affairs but all were elated to be going on what they regarded as a great adventure. Those of British birth, and Silas was one of them, were conscious of helping "Mother England."

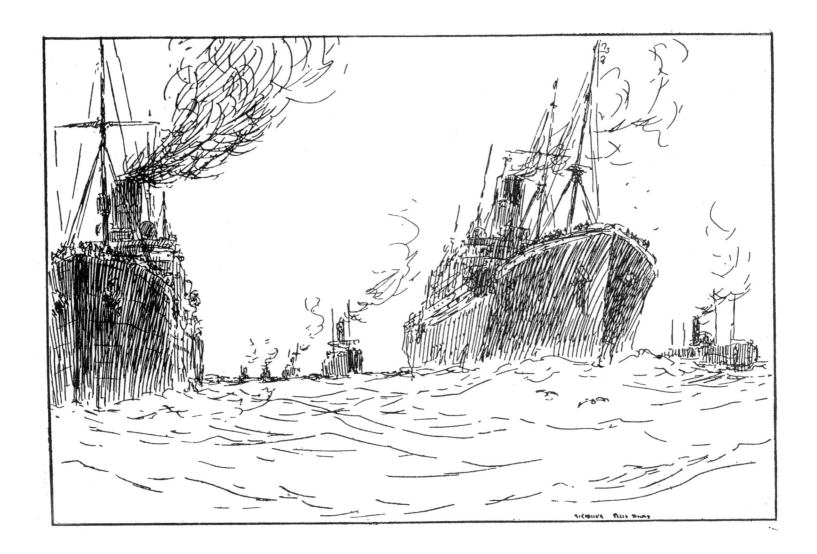

"WALKING STICK! cigarette flag! cigar, pos' card! B'ery goo-o-d!! B'ery nice. Australia,' B'ery goo-o-d!! Baksiesh. Gib. it –'a1f piastre – Mr. McKenzie; I know you, b'ery nice, quies Katieah!!!"

The Cairene is an indefatigable vendor. Why he is not wealthy is a mystery. Whether you meet him miles out in the desert, or in some equally remote spot, he has always got something to sell you. Should you, perchance, happen to be falling off a donkey — or the top of the Pyramids — you would probably find a horde of Arabs rush forward and endeavour to sell you something during your meteoric flight through space. Though the Egyptian is cunning, his artlessness is delightful; he will usually begin by asking a fabulous sum for his goods, and will be quite pleased if, in the end, he obtains the equivalent of a penny-farthing.

Egypt, Jan., 1915.

In Arabic, a bazaar is a souk and it was an exciting place for young men who had never travelled far from their home. The street sellers offered them carved walking sticks, cigarettes, small national flags, postcards and much else. They often begged for "Baksheish" or "Baksheesh," meaning money; a half-piastre (less than a halfpenny) would do. To the vendors, all British and Empire soldiers were "Mister McKenzie," though after a time they used "Aussies." A frequent cry was "Quias katieah!" This means "Wait a while" and was directed at the soldiers who were hurrying past.

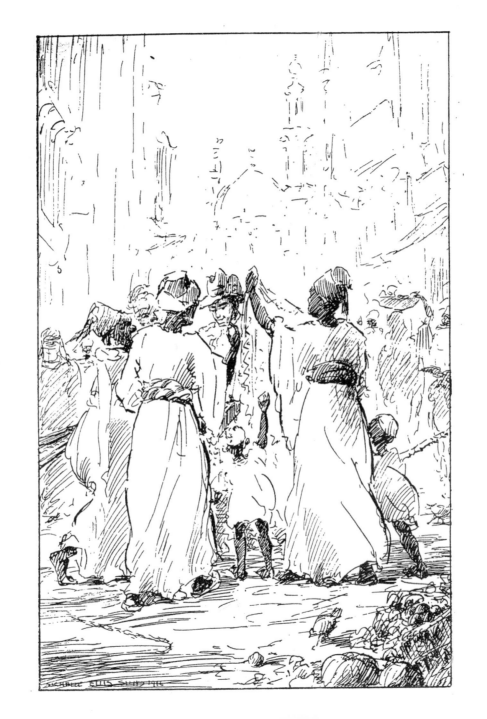

RIDING is not my strong point. I wear leggings because they look nice. Some of the boys would spend the whole evening in that most diverting pastime, donkey racing. The Donkey-boys made much money and shed many tears. Often, when returning to camp, I would come upon a Donkey-boy, who was usually a man, weeping copiously over the loss of half a piastre, or something equally trivial. It takes very little to bring tears to the eyes of a Cairene.

Egypt, Jan., 1915.

As an infantry soldier, Silas was not entitled to wear the leather leggings worn by the men of the Light Horse. As he says, the leggings "looked nice." He also wore his slouch hat in a way that 'looked nice' and was frequently ordered to put it on in the regulation way. Tall Australians riding the little Arab donkeys and urging them along like racehorses were one of sights of Cairo in 1915–16.

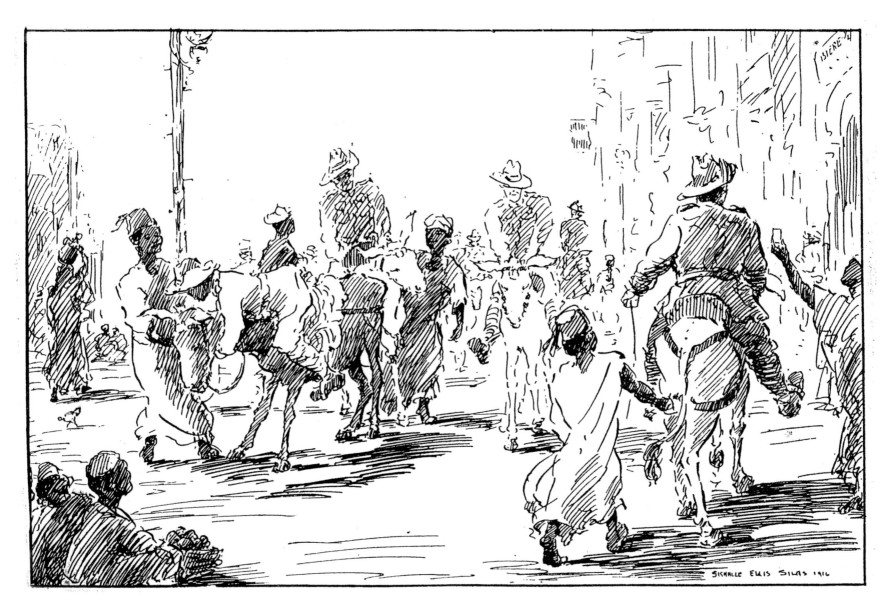

"Egyptian Timees — This morning's news to-day."

Egypt, Feb., 1915.

Paper sellers did a brisk trade in Cairo among the Australian and New Zealand troops. The English-language newspapers were of good standard and up to date. Every event was good news to Cairo's paper sellers. "Verree good news!" they shouted on the occasion of a great British disaster, "Kitchener dead! Kitchener dead!" Lord Kitchener, the British Minister for War, had drowned when a destroyer taking him to Russia was torpedoed in the English Channel.

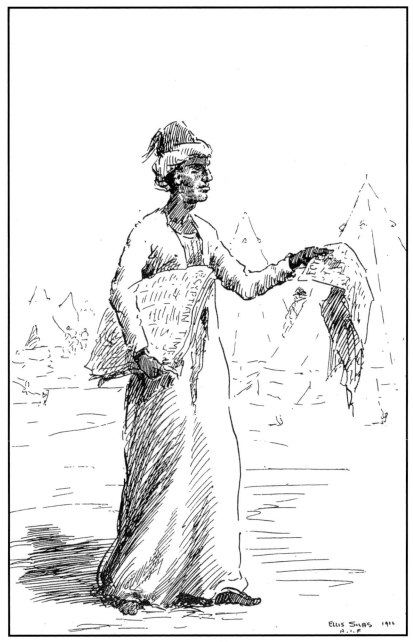

Heliopolis — Oranges.

"Oringees, three for 'arf piastre, big one! Gib it!"

Egypt, Feb., 1915.

The fruit sellers of Cairo found that Australians and New Zealanders had a great appetite for fruit and as they were better paid than the British troops they could afford to buy it. The vendor whom Silas sketched was offering three big oranges for half a piastre but the Australians, bargainers, would finish up with six for half a piastre. "Gib it!" simply meant "Buy them."

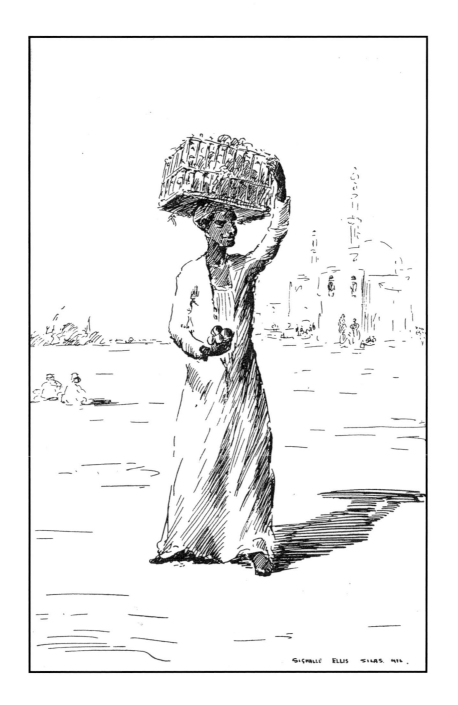

Heliopolis — Cooked Eggs.

"Eggs a Cook!"

Egypt, Feb., 1915.

Hard-boiled eggs were popular among the troops. This seller's simple cry became important in Australian military history. "Eggs-a-cook!" became an Australian battle-cry, especially for the 3rd Division, whose colour patch was oval-shaped, like a hard-boiled egg "lying down."

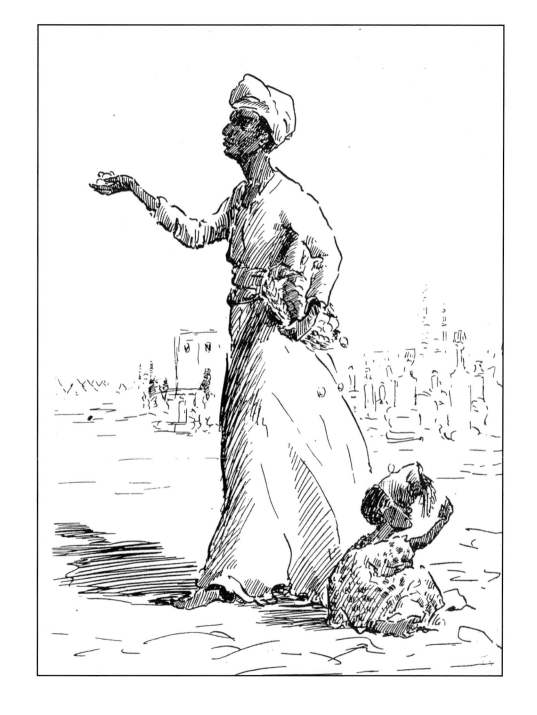

Heliopolis — The Bootblack.

"Ki wi, Clean er boots! No good — No money!
Mr. McKenzie!"

Egypt, Feb., 1915.

The shoeshine boys of Cairo did a brisk trade. The famous Kiwi polish, which they used, produced the best finish, they promised. If they did not do a brilliant job, they expected no payment. It has to be said that many a "Mr McKenzie" did not pay up for a job well done.

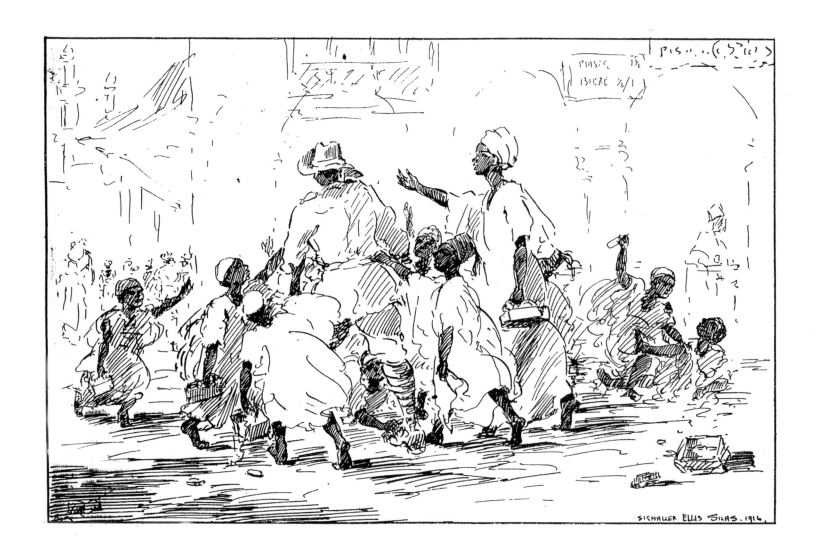

Sylvan Quietude.

IT was a welcome diversion to get ashore, after being cooped up in a transport; a pleasant change to be marching along hard roads, in place of the wearisome toiling across the desert sands of Egypt. The rich fresh green of the pastures, splashed with brilliant scarlet poppies, the sheep grazing peacefully on the hillside, truly a sylvan quietude. As we sat in the village, tranquilly smoking, from afar we could hear the ominous thunder of distant guns. It was difficult to realise that soon— very soon—we were to exchange this peaceful scene for one of colossal strife; to mete out and receive death in a hundred hideous shapes; to climb a hillside splashed with scarlet, that was not of poppies.

Lemnos, April, 1915.

The Australians were pleased with the look of Lemnos island, which had been lent by the Greeks as an Allied base. Mudros Bay was the finest harbour available and it was a busy haven. However, though Lemnos was only 60 miles from Anzac, in the neighbourhood of Mudros, where the men were to be camped, there was water for only a few thousand men. Ellis Silas and his mates obviously enjoyed their few days on Lemnos but many troops were kept confined to their troopships in Mudros Bay.

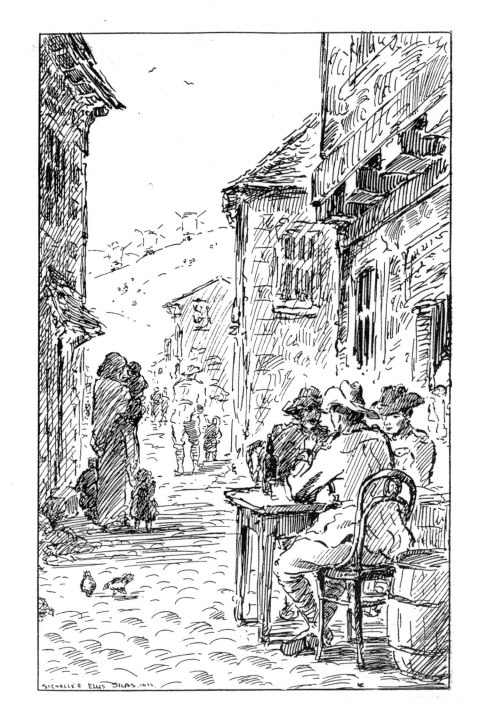
Signaller Ellis Silas. 1916.

The Real Thing at Last!

A T first, it was a little difficult to realise that every burst of flame, every spurt of water, meant death —and worse. For days before we reached the final scene in the "Great Adventure," we could hear the ceaseless thunder of the bombardment. We were told of the impossible task before us, of probable annihilation. Yet we were eager to get to it. We joked with each other about getting "cold feet," but deep down in our hearts we knew, when we got to it, we would not be found wanting.

Gallipoli, April 25th, 1915.

It is clear from Silas' comments that the troops had been warned of the "impossible" nature of their task but the vision of the "Great Adventure" was still powerful. The crusade was beginning.

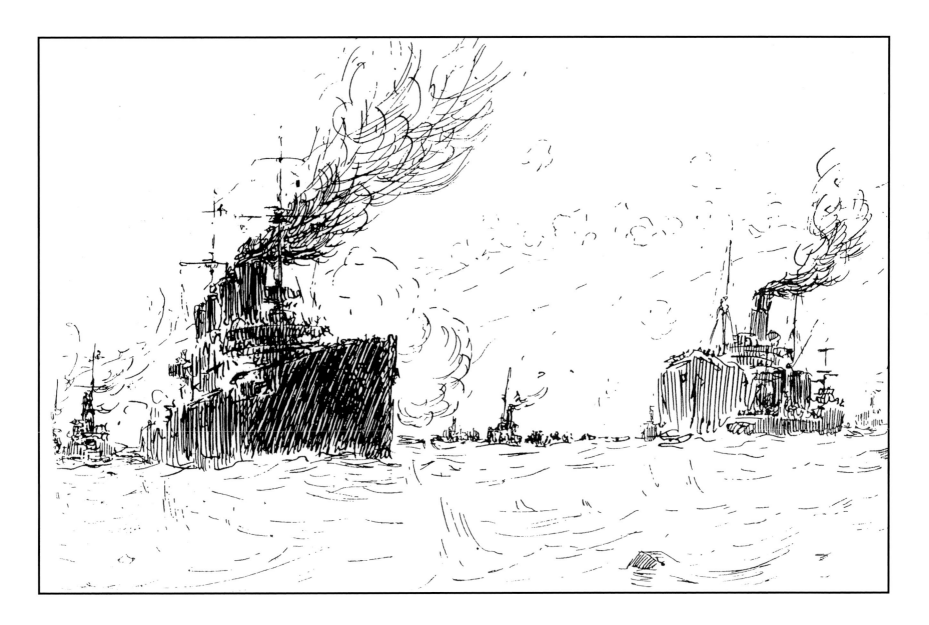

The Last Assembly.

IN the hold of the troopship, "Hyda Pasha." There, for the last time in this world, many of us stood shoulder to shoulder. As I looked down the ranks of my comrades, I wondered much which of us were marked for the Land Beyond. We were well in the zone of fire, and every second I was expecting a shell to come bursting through the side of the ship, to answer my question.

Gallipoli, April 25th, 1915

As each man's name was read from the roll, he climbed the steps from the hold onto the deck. Silas' apprehension that a Turkish shell might smash into the ship was shared by his mates.

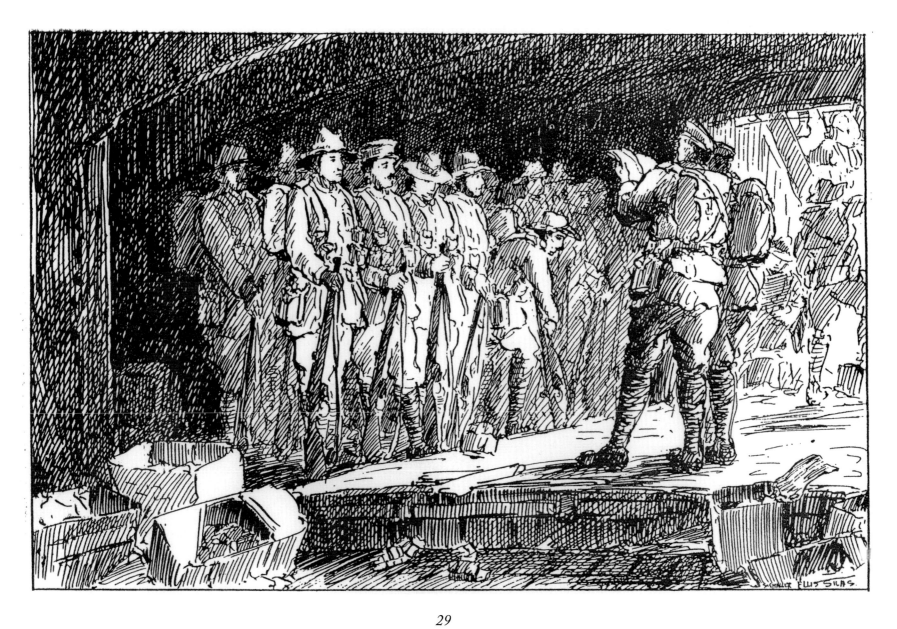

Boarding the Destroyer "Ribble."

WE were very tightly packed. One of the Boys said: "Mind where you are stepping. Silas." I looked behind me; there, lying in a row, half covered by tarpaulin, were three silent forms— one of them a signaller! I had often been told of the dangers of signalling—that few signallers lasted more than three days. Now, indeed, was this brought home to me with considerable force. Once more I prayed that I might not fail my Battalion in the hour of need, because I knew full well that the miscarriage of a message might mean the lives of hundreds of men. The sailors were very kind to us, having fully realised that we were, many of us, going to certain death. Their "sang froid," when the shrapnel was raining down on them, was splendid!

Gallipoli, April 25th, 1915.

Silas had not wanted to be a signaller and now, as he transfers from the troopship to a destroyer, which could move closer inshore than a big ship, he almost treads on a dead army signaller. It must have been a sobering moment.

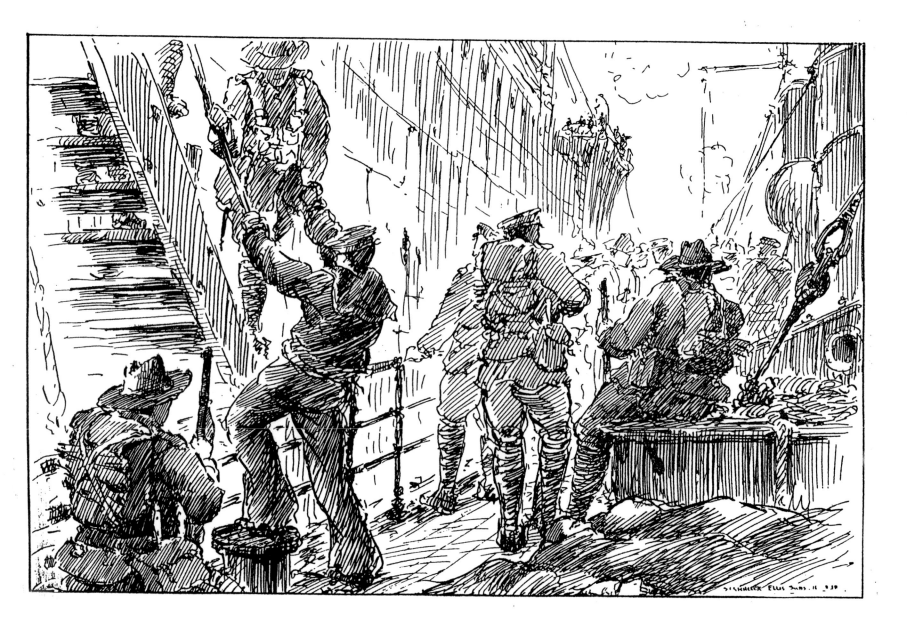

From the "Ribble" to the Boats.

WE were transferred from the transport to the destroyer, which took us close into the shore, and then we were transferred into the ship's boats and rowed to the shore, amidst a hail of shells.

Gallipoli, April 25th, 1915.

Boats from the destroyers, each one under the command of a young naval midshipman, rowed the troops ashore on the morning of 25 April and as Turkish sentries spotted them in the breaking dawn the troops came under fire.

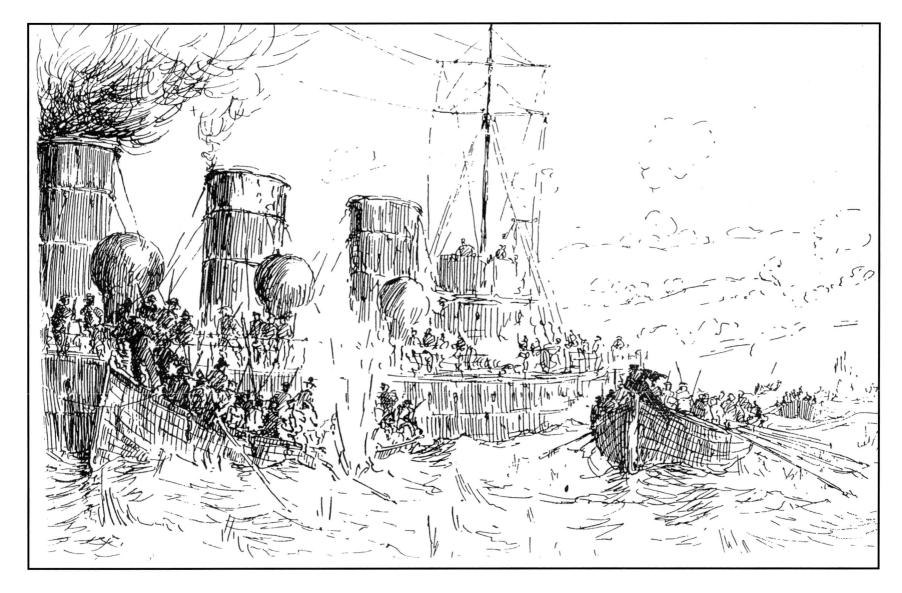

The Landing.

IT was a relief to get ashore. We were packed so tightly in the boats and, moreover, so heavily laden with our kit, that had a shot hit the boat we would have had no chance of saving ourselves. It was awful, the feeling of utter helplessness. Meanwhile, the Turks were pelting us hot and fast. In jumping ashore, I fell over; my kit was so heavy that I couldn't get up without help. Fortunately the water was shallow at this point, otherwise—well, I'm here to relate the incident. It was a magnificent spectacle to see these thousands of men rushing through this hail of death, as though it were some big game.

Anzac, April 25th, 1915

Most of the Australians in the first landing spoke of their relief at jumping ashore from the overcrowded and terribly vulnerable open boats. Some of the men were drenched by the splashes when enemy shells hit the water at Anzac Cove.

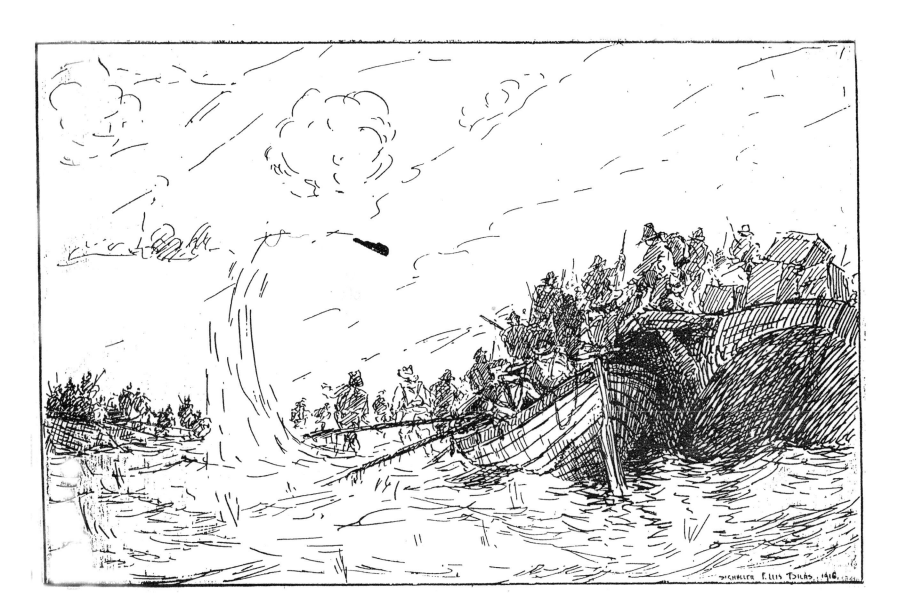

THIS was the most advanced position, at that time, and quite the hottest corner in Anzac. Every few minutes, with sickening monotony, would sound the cry—"Stretcher bearers!!" Poor fellows, how magnificently they worked. This drawing gives an idea of the nature of the ground across which they had to carry the wounded; and when it rained, it was well-nigh impossible to obtain a foothold. The shells seen bursting are from our own ships. The hill on the left was stiff with snipers. The dome-like dug-out, half-way down the edge of the hill, was the quarters of Major Mansbridge. All his signallers were put out of action by snipers, so I had to do the work of A and B Companies—signals and despatches—alone. I think the Turkish snipers were keenly interested in my movements, too much so for my liking. I like people to take an interest in me, but there are times when I wish they wouldn't.

Anzac, April, 1915.

The hill was named after Colonel H. Pope of Perth, born in 1873, who was later decorated with the Companion of the Order of Bath. When Silas claims to have been the only signaller remaining for two companies of infantry — perhaps 200 men — he was stating the truth. Major (later Lieutenant-Colonel) W.O. Mansbridge of Coolgardie, Western Australia. Mansbridge had been born in England in 1872.

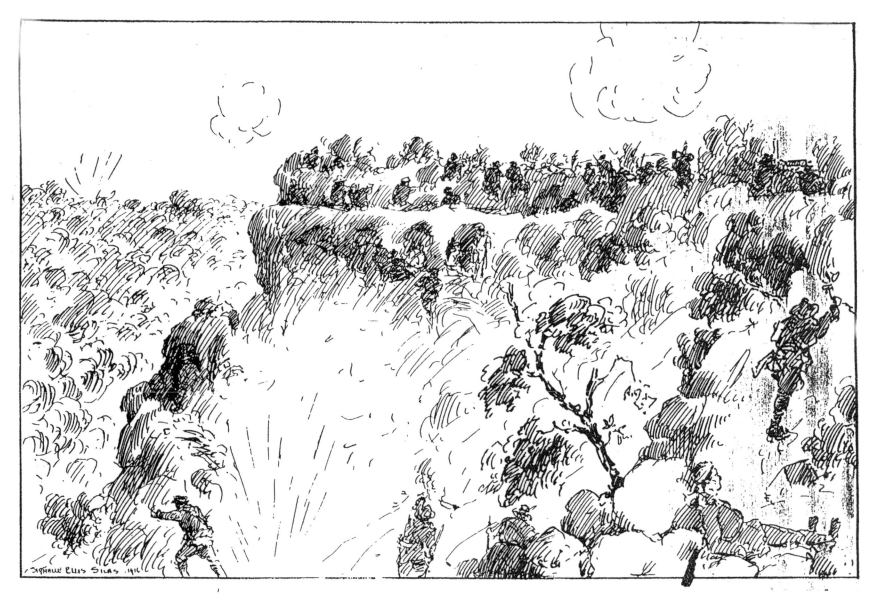

"Dead Man's Patch."

IT was across this exposed spot that many times I had to run despatches. The ridge on the right, where shrapnel can be seen bursting, was thick with snipers, who had this patch so well set that they rarely missed their mark. The poor chaps seen in the drawing all got caught when trying to get across. I wondered if I was to join them.

Anzac, May, 1915.

In his description Silas refers to shrapnel bursting and he indicates it by the cloud-like puffs of smoke. A shrapnel shell contained thousands of steel or lead balls, the size of marbles. An explosive charge in the base of the shell forced out the shrapnel which sprayed down with great velocity on the infantry below. Steel helmets had not yet been developed and many soldiers were killed by shrapnel balls in the brain. A high explosive shell did not contain shrapnel but, generally on impact, broke into great shards or splinters which caused fearful wounds.

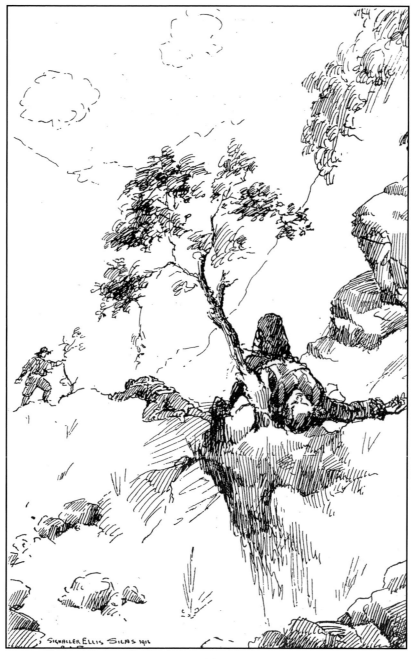

My First Dug-out.

THIS bit of a hole took me four days to dig. I was not strong enough to lift a pick, so had to do what I could with my trenching-tool; also I was kept so busy signaling, as I was the only signaller left out of A and B Companies. As soon as I would commence to work on my dug-out, I would hear the everlasting cry "Signaller!!!" So up I had to get with my flags. The thick scrub on the hill to the left was "stiff" with snipers; in fact, it was safer in the firing line than out of it. The poor fellow lying on top was my only companion for three days; that silent reminder of what I might any second be myself, was not pleasant. It was impossible to bury him. To put one's head above the bit of earth I had thrown up was to court death. How I escaped being hit is wonderful, for I had to get out of my hole every few minutes. It is not with any desire for morbid sensationalism that I introduce the dead in every drawing. They were part of our daily life; they were part of the character of the Peninsula — at least of Anzac.

Anzac, April, 1915.

The dead were a part of daily life — in this apparently odd statement Silas meant exactly what he said. Scores of soldiers died every day and after a short time the survivors accepted the heavy casualties as inevitable, almost as "natural." So great was the misery of the living that they envied the dead.

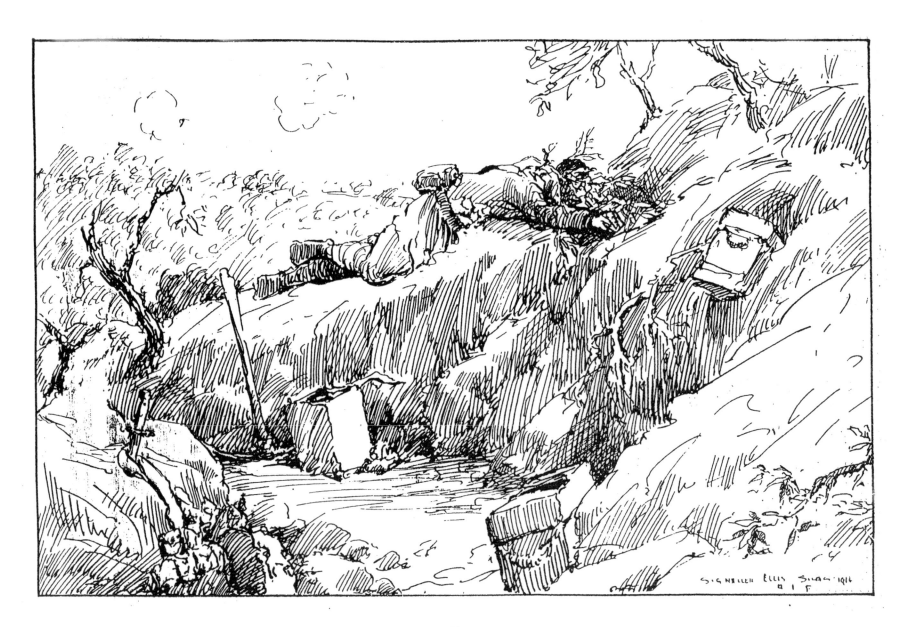

41

ONE of the most trying experiences was when our ships mistook the range, and began to plump shells into us; when the Navy gets on its mark — it's a hit every time. They put eleven shells into us before we could signal to them to alter range; and the Turkish trenches were so near ours that it made it very difficult for the ships to get the correct range. I was covered with earth from the explosions. I quite thought the next shell would strike my dug-out, and finish me. It is some seconds before the debris drops to the ground, and one quite realizes what has happened.

Anzac, April, 1915.

Gunfire from the ships of the Royal Navy caused many casualties among the Anzacs and the British troops, sometimes because the naval gunners did not have a clear idea of the location of their own troops. The Turkish and Australian trenches were often so close together that the slightest miscalculation on the part of the ships' gunners would drop a shell right into a trench full of Anzacs. Also, some fuses were faulty, resulting in "drop-shorts."

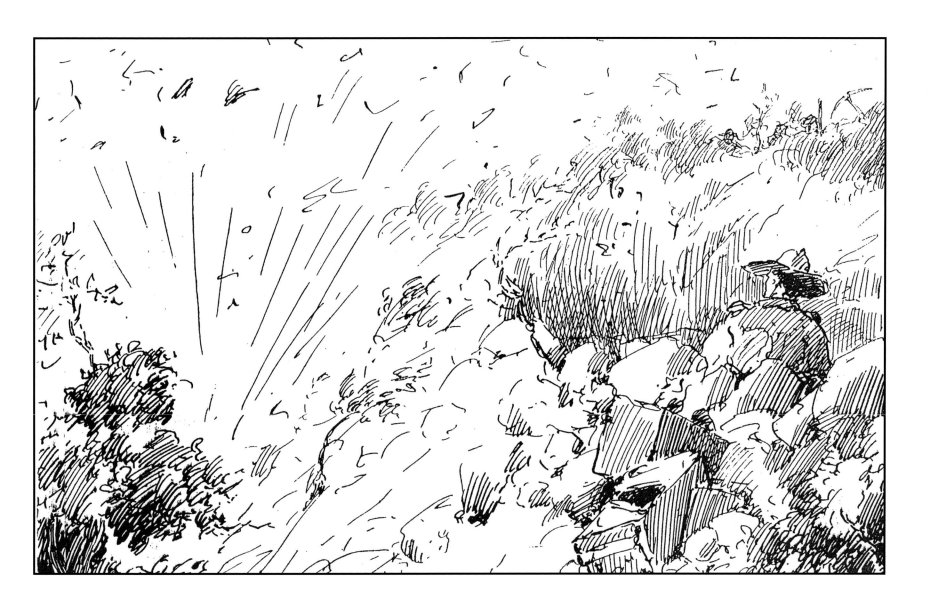

At the Water Hole.

THIS was always covered by the Turkish snipers; in fact, it was safer in the trenches than at this place. It was quite one of the warmest spots at Anzac. The poor fellow in the dug-out was caught, just a few minutes before I filled my water-bottle. All round here were wounded and dead men, who had been hit when dodging round this corner. However, one must drink, even if the price be death.

Anzac, May, 1915.

The soldiers were thirsty all the time in the harsh heat of a Gallipoli summer. Some supplies reached them in containers but often they were forced to risk their lives to fill their water-bottles at a spring. The Turks knew every metre of the battlefield and hidden snipers easily picked off the desperate Australians. Sometimes their blood filled the waterhole.

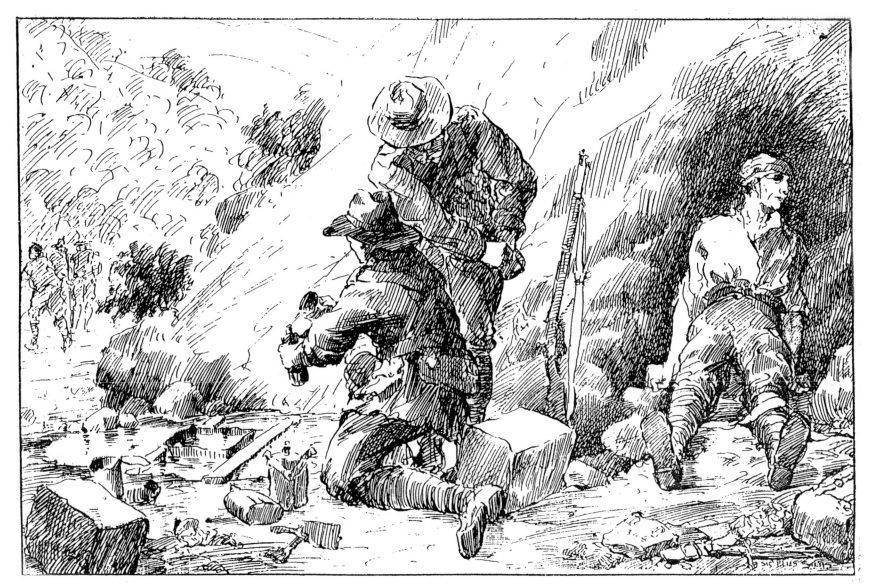

The Snipers.

THE snipers had been causing us a •deal of trouble. It became almost impossible to go round this corner without getting hit. Finally we were unable to bring up our supplies. The poor chap in the foreground was shot a few minutes before I made this sketch; and the pack-horse severely wounded. Despite the great danger, two men rushed forward and caught hold of the startled animals, thus preventing a stampede which, in the confined space of the narrow road — if such it could be called — might have caused an impasse, and this under the existing conditions would have been highly dangerous. The repetition of shrapnel in each sketch is not a fad of mine, but just the natural order of things: they became as much part of the landscape as the clouds.

Anzac, May, 1915.

Some Turkish snipers killed scores of Anzacs but it should not be forgotten that Australian and New Zealand crack shots built up formidable scores. One Australian, Trooper Sing, is believed to have shot about 200 Turks.

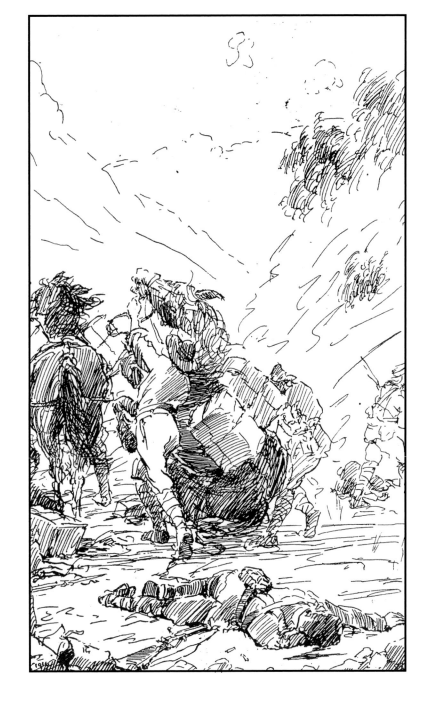

The Last of a Comrade.

THIS poor chap was shot while in his dug-out. He was lying there two days, his billy-can full of tea, the charred remains of the fire he was cooking by, a few biscuits scattered about, and his pipe by his side. At dusk we crept out and buried him, on the spot that had been his resting-place when not in the firing line. There he is still resting—awaiting the "Last Assembly."

Anzac, May, 1915.

Gallipoli graves were always shallow because the ground was too hard even for a pick and because soldiers were dangerously exposed when digging and therefore did the job in a hurry. Writing in 1916, Silas says that his mates killed in 1915 were still resting there. Proper burials had to wait until 1919, after the war had ended. Australian War Graves officers were then able to visit Gallipoli to identify fallen soldiers, where possible, and to bury them.

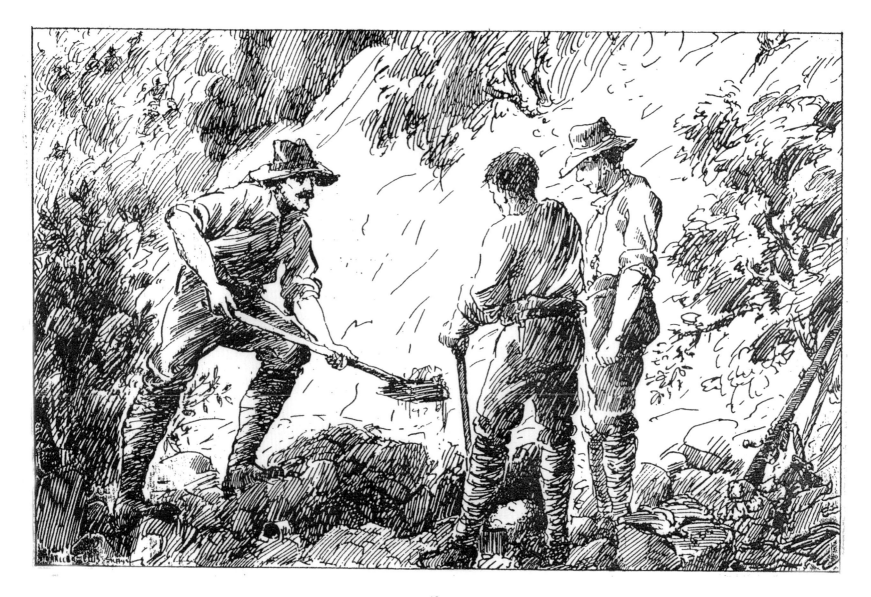

Bloody Angle.

THIS trench had been giving us considerable trouble, owing to its position. It overlooked the road through which our supplies were brought. Eventually it became quite impossible to get further stores through. This naturally caused great anxiety. So at dawn, May 2–3, we were ordered to storm the heights. It is difficult to describe the almost impossibility of the task. It was a sheer slope of sandy soil, which made it extremely difficult to obtain a foothold. Up we went, and, despite the murderous fire that was poured into us, we sang "Tipperary." The cries of the wounded, the tremendous fusillade of rifles and screaming of shells, were indescribable. Quite impossible to hear orders, it was each man for himself. We knew what we had come to do, and we did it — at a price! It was on this occasion that the 16th Battalion was practically wiped out. One fellow whom I came across frightfully wounded, said: "My! but they're willing." Another poor man came tearing along, his right hand blown off, waving the bleeding stump, and calling out: "My God! but I've done my duty!!! Hallo! that you Silas, old chap, I've done my duty, haven't I?"

Anzac, May, 1915.

Capturing the enemy positions at Bloody Angle required great courage and fortitude and cost many Australian lives. The 16th Battalion, Silas' unit, suffered heavily. The unit, commanded by Lieutenant Colonel J.H. Cannan of Chelmer, Brisbane, landed on 25 April with 17 officers and 1000 men. On 2 May it entered the Bloody Angle assault with 9 officers and 620 men. By the following day 8 officers and 330 men were casualties. Many a soldier regarded a wound as lucky; it took him out of battle, possibly to survive — if he did not bleed to death before he reached the beach.

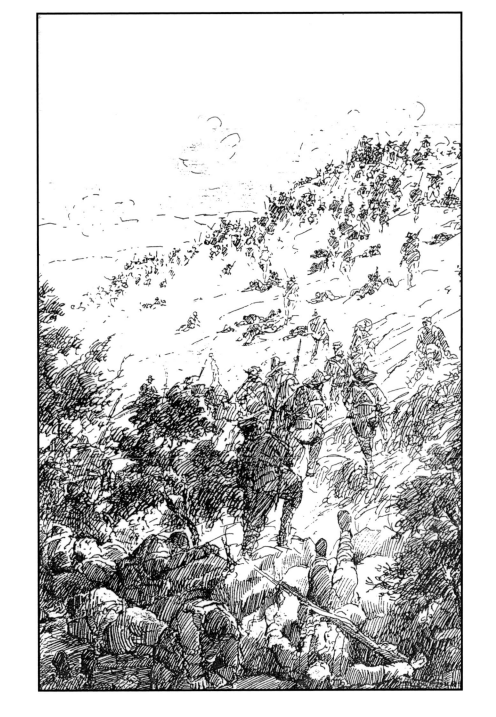

At the Top of the Hill.

O F this magnificent and terrible charge at Bloody Angle, which decimated our ranks, I have already spoken.

Anzac, May 2nd, 1915.

The fighting of 2 May was sustained and it was often hand-to-hand, with soldiers on both sides using bayonets, clubs and rocks. There was no opportunity to help the wounded, which profoundly worried those Australians who stayed on their feet.

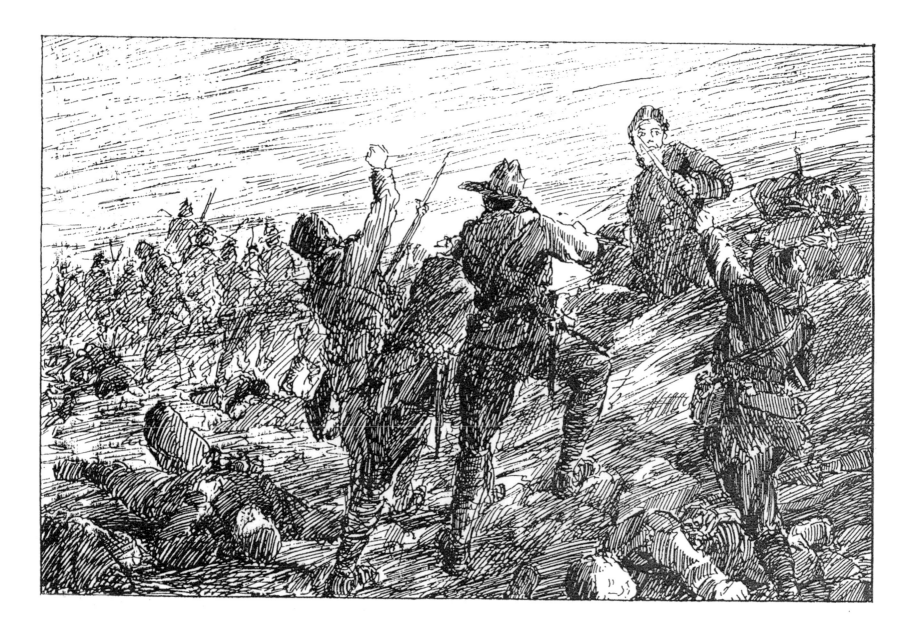

Dawn.

I SHALL never forget the indescribable scene in the gully; it was choked with dead and wounded. These poor lumps of clay had once been my comrades—men I had smoked and worked and laughed and joked with. Oh God! the pity of it! It rained lead in this gully. All round could be seen the sparks where the bullets were striking. It was amidst this hail of bullets that General Godley calmly did up my puttee for me. I implored him to take cover, knowing we could ill spare the loss of a General. But he wouldn't hear of it; every second I was expecting to see him hit. But not until he had done up my puttee would he move. Then, with an amused chuckle, he passed his hand across the top of his cap, at the same time remarking: "That was a pretty near thing." A bullet had singed the top of his cap!!!

Anzac, May 3rd, 1915.

Silas refers here to Major-General Sir A.J. Godley, who commanded the New Zealand Expeditionary Force. An Irishman by birth, Godley on 29 May ordered the recapture of Quinn's Post.

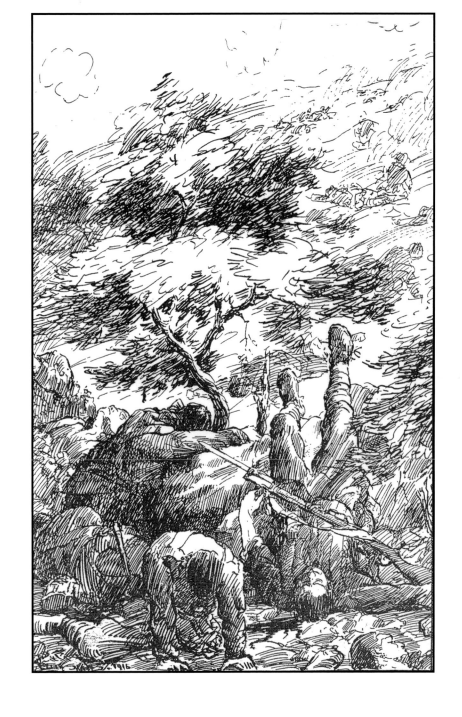

The Stream of Wounded.

FROM daybreak there had been a ceaseless stream of wounded—in many cases they died on the way down—until in many places the pass was so cumbered with the dead and badly wounded, waiting for the stretchers, that it became impassable. Along the edge, bodies were hanging in all sorts of most grotesque and apparently impossible attitudes. Seeing those fine stalwart men going up the gully, and shortly returning frightfully maimed and covered with blood, was a sight I shall never forget. One poor fellow, a New Zealander, came tearing down the gully, smothered with blood, and quite delirious, kissing every man he passed, upon whom he left a splash of blood. Some would come along gasping out their lives, suddenly drop, then remain silent—for ever. The ridge where the shrapnel is bursting was the one we took on the night of May 2–3, now an historical event. We had to abandon this ridge, and so were never able to bury our poor fellows, who can be seen lying on the hillside.

Anzac, May, 1915.

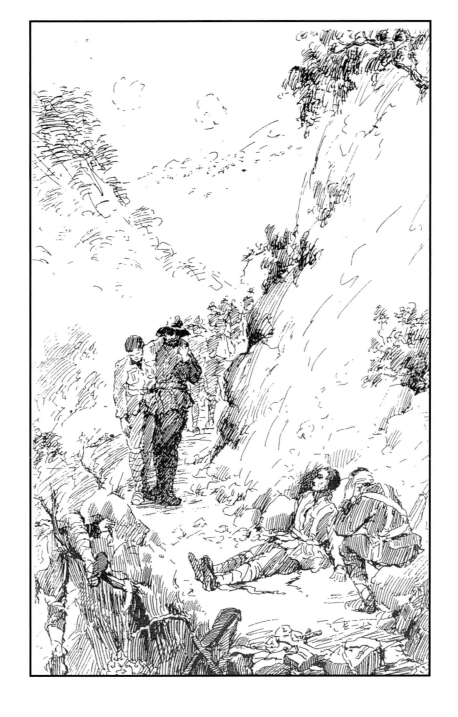

Stretcher-Bearers.

THIS gives some idea of the difficulties and dangers the stretcher-bearers had to contend with. Their bravery was quite equal to any heroism shown on the field of battle. When we first landed, the Turks shot at anything that moved, sparing not even the wounded on stretchers. They had been told by the Germans that the Australians were cannibals.

Anzac, May, 1915.

The Turks, mostly illiterate Anatolian peasants, readily believed the lies of their German allies that the Australians were savages and cannibals. Silas' drawing shows something of the difficulties and dangers of stretcher-bearing. It was an exhausting duty and normally four men were required to carry a wounded man. The life expectancy of a bearer was at most two weeks.

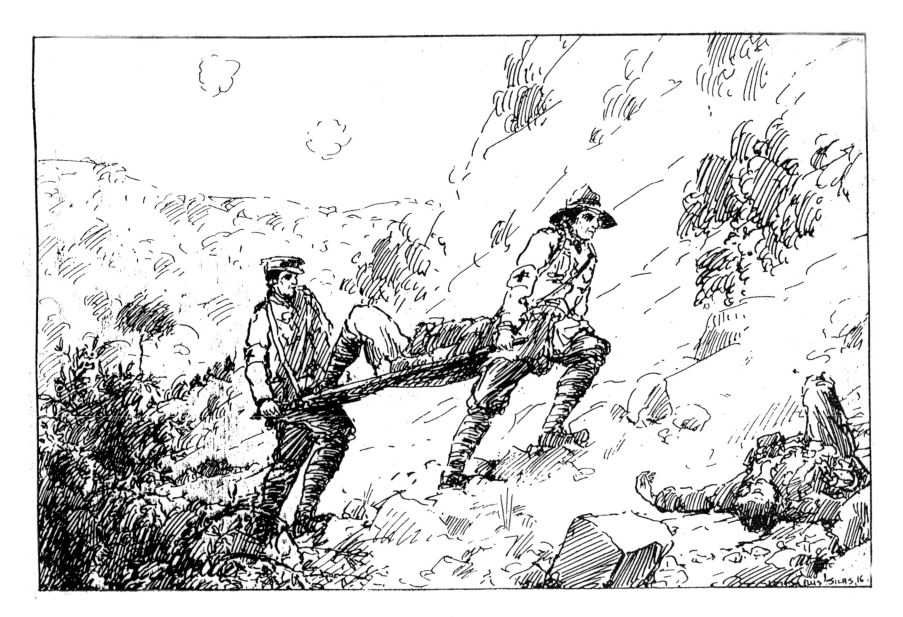

59

A Field Dressing Station.

THIS was quite one of the saddest sights on the field of battle. Here the medical officers fought hard for the lives of what had once been magnificent specimens of manhood. Note the poor fellow on the left, his puttee undone, ready to have his wound dressed; but he slipped away into a land where pain is not—thus it was with many.

Anzac, May, 1915.

Doctors and their helpers did their best with inadequate equipment. They lacked anaesthetic and antiseptics and often they were unable to sterilise their instruments. Field dressing stations were usually within rifle shot of the enemy. From here the disabled men, their wounds dressed, were carried to a field hospital near the beach and from there they were taken to Lemnos Island.

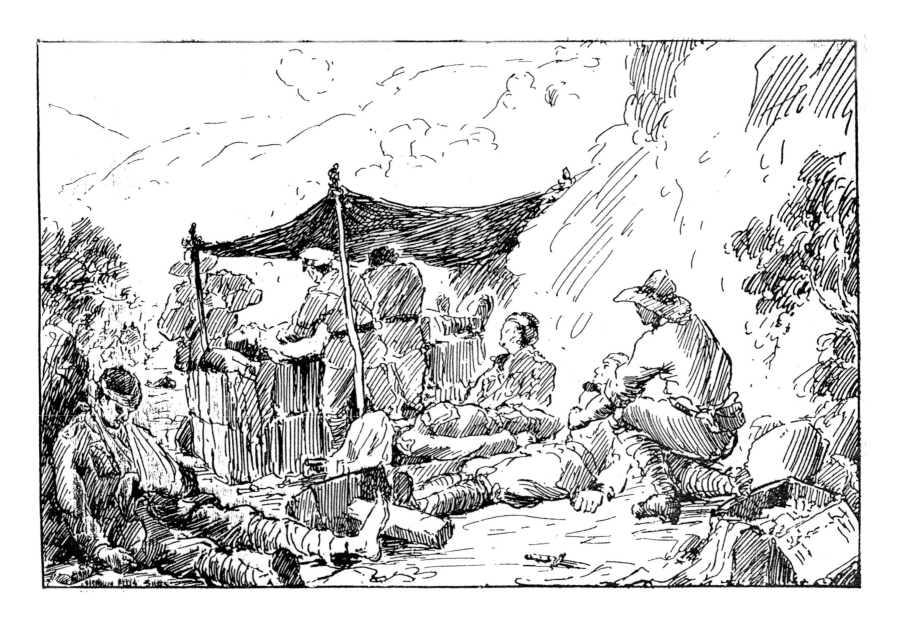

61

Bathing under Shell Fire.

THIS was certainly a most unique experience. I remember how delightful it was to be immersed in the sea, after not having had a decent wash for about three weeks. We would hear the enemy's gun fire, then: "Shell 0!!" Out we would all scamper like a crowd of naughty schoolboys and take cover behind anything on the beach that afforded shelter. Then, after the shell had burst, back we would go into the sea. I remember the beautiful colour of the water, and the ships lying out on the horizon. "Shell 0!!" This time we were nearly caught, for two or three shells came sliding through the air and burst quite close to us; however, we were determined not to be done out of our swim, so back into the water we went.

Anzac, May, 1915.

Swimming was the only pleasure at Anzac but relatively few men had the opportunity to swim. Casualties were so high from wounds and illness that every man who could stand was needed in the trenches and tunnels.

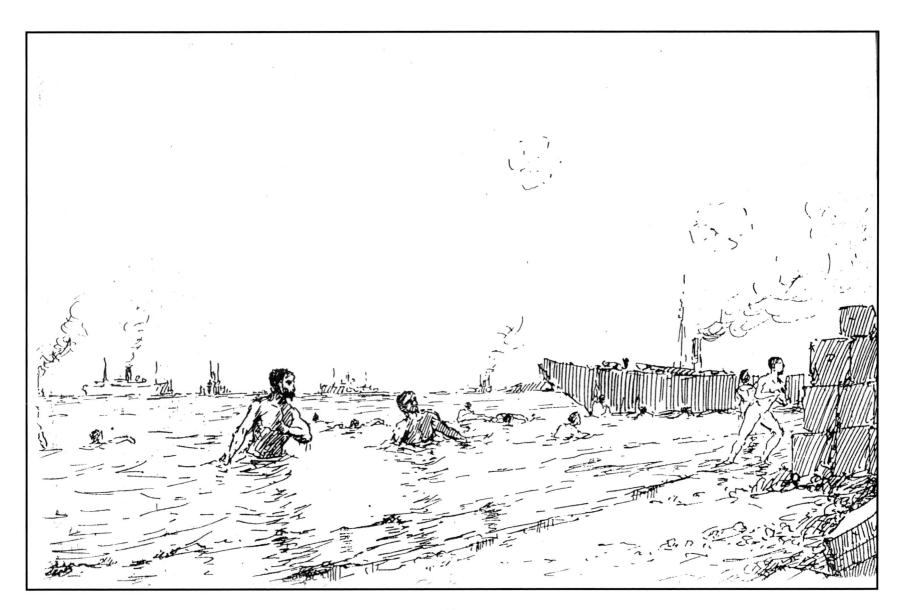

In the Trenches—Quinn's Post.

THE Turks' trenches were only a few yards in front of ours. They caused us much trouble with bombs. The poor chap on the left was badly caught, but I don't think he knew much about it. He was lying there some days. Though I often had to climb over him when going through the trenches, I didn't dare look at his face—if there was any—he was such an awful spectacle. The man on the right "caught it" badly; whether he died I know not. There was little time to think of these matters. He was out of action; another man must take his place.

Anzac, May, 1915.

The post was named after 29-year-old Major H. Quinn, who was killed on 29 May. The soldier in the middle of Silas' sketch is using a trench periscope to spot for enemy movement; then he would snipe a Turk. The enemy sharpshooters had the advantage of always being on higher ground than the Australians. One of Silas' officers, Captain Burford Sampson, of Launceston, distinguished himself on 9 May and should have been decorated.

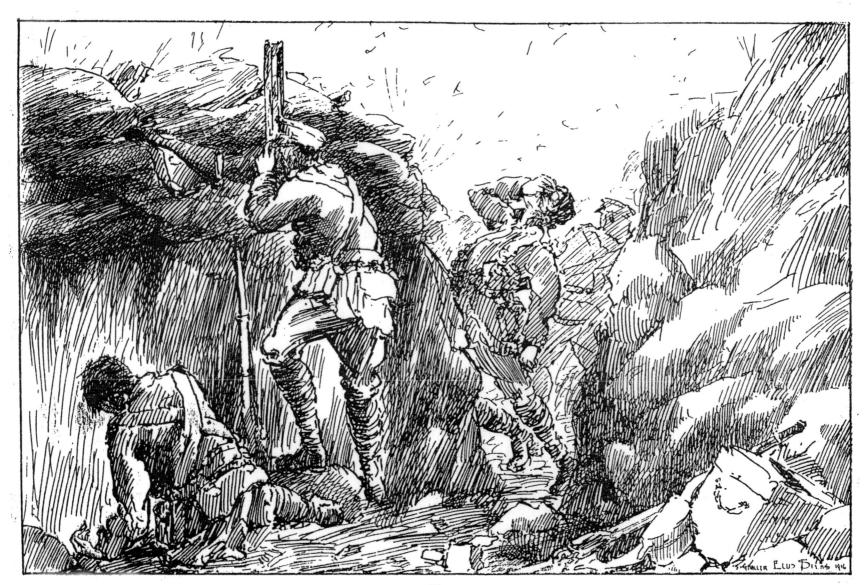

Signalling — Quinn's Post.

S nipers created a considerable amount of dust, every time I got up to signal. In fact, I think they had a real merry time, but being so sure of their mark they became careless. Well, whatever the cause, they didn't get me. The feet above are those of a buried comrade. It was not an unusual occurrence when "digging-in" to come in contact with a grave.

Anzac, May, 1915.

Most signalling was done by flags, with the signaller sending semaphore messages. To do this he had to stand up and expose himself to enemy fire. Signaller Ellis Silas was incredibly lucky to escape being hit. The dead men whose legs protrude from a shallow grave would not have kept his boots for long. Some soldier, his own footwear worn out, would have taken those of a dead mate.

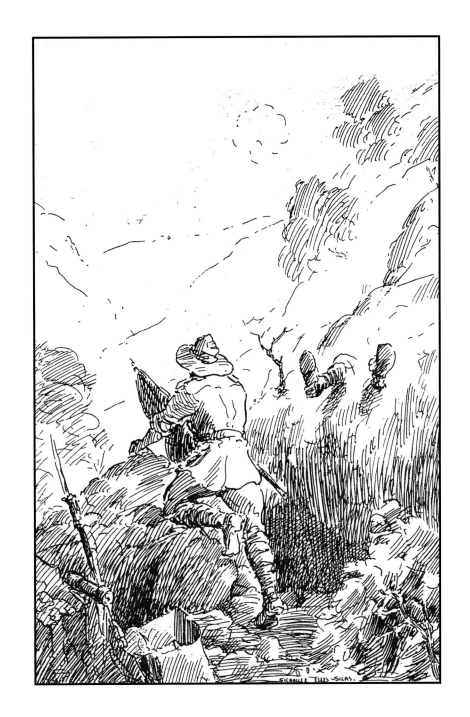

Shrapnel Gully from Quinn's Post.

MANY an anxious moment we spent scanning the horizon for a sight of the transports which were to bring the much needed reinforcements; for the Turks were pressing us very hard. We were only just "hanging on," expecting any moment a final rush from the enemy; for they were our superior in numbers. The man on the left was shot by a sniper just as he was leaving his dug-out.

Anzac, May, 1915.

From these heights, soldiers looked down on the peaceful Aegean Sea and fervently hoped that fresh troops would soon relieve them on the frontline. Struggling up from the beach through the steep and rocky ravines was exhausting. Silas faithfully illustrates what he himself would have done many times.

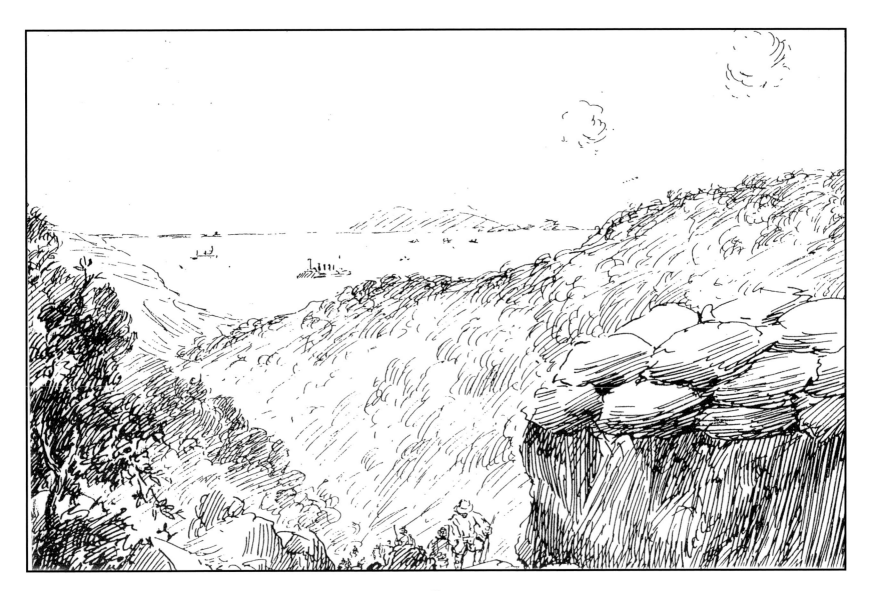

"STAND TO ARMS!" "B Company will advance." Just before dawn; every morning, we had to "Stand to Arms" in readiness for a probable attack. It was all very eerie, dreary and cold in the thick morning mists; we would appear and disappear like phantoms. On this particular occasion, we were in for a hot time. I shall never forget how weak and helpless I felt—I think fever must have got a firm grip of me, I wondered how many of us would be left by sunset. The figure in the centre is Capt. Margolin, such a fine fellow, and brave beyond compare, though it is difficult to say who wasn't during these first terrible weeks. He could not do enough for his "Boys," as he called us. On one occasion, during the charge of the Light Horse, which I have mentioned elsewhere, when we, the 16th Battalion, were sent into action by mistake—"I must get my Boys out of it," he said, "there will be none of them left!"

Anzac, May, 1915.

The soldiers dreaded the early morning because just as they were at their sleepiest they had to be fully dressed, with rifles in hand, as they lined their trenches to repel a Turkish attack. Like most AIF officers, Major E.L. Margolin — Silas mistakenly calls him a captain — thought about his men before himself. The official historian, C.E.W. Bean, said that Margolin, with "a faithful assistant, Signaller Silas," succeeded in getting 40 men of the 16th Battalion back from No Man's Land to Quinn's Post.

Margolin, who was born in Russia in 1875, came from Collie, Western Australia. He became a lieutenant-colonel and was awarded the DSO.

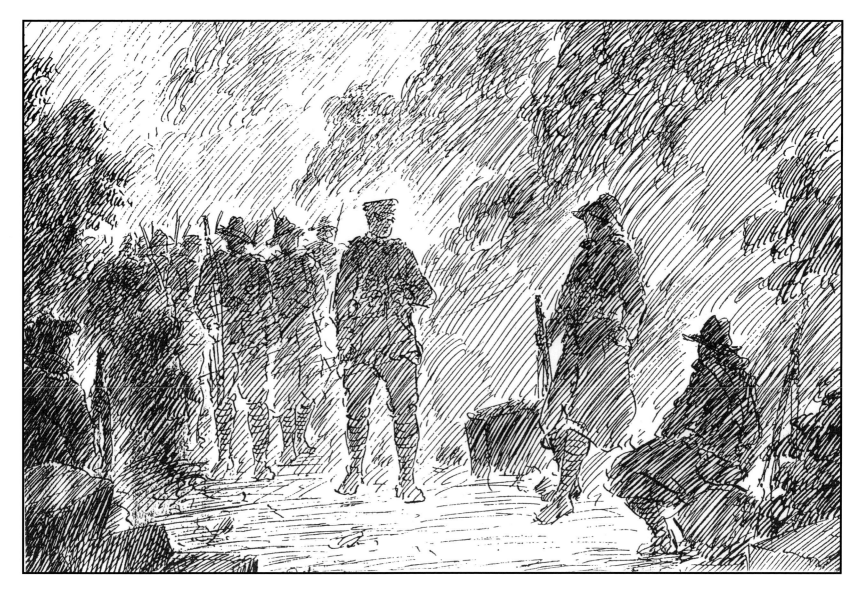

THESE trenches, facing Quinn's Post, had been giving us a hot time, causing many casualties with their bombs. After the trench was captured—the forty yards of flat ground between this, our new front and our own trenches, was swept by the enemy's fire, which was enfilading us. The 16th Battalion was only supposed to reinforce, instead of which, by some error, we were sent into the firing line; but there was not room in the trenches for all — many had to lie outside. I had to go six times across this lead-swept plateau until eventually I could find the 16th Battalion, and deliver the order to retire. In the darkness I had not noticed a communication trench, which would have obviated the necessity of my crossing this lead-swept space. What worried me most was that I might fall over the decomposing bodies of the dead Turks. The figure in the centre is that of Lieut. Harwood. When I got to him with my message he yelled above the din: "Silas, this is fine, I wouldn't be elsewhere for a thousand pounds!"

Anzac, May, 1915.

Every victory was won at a terrible cost in men. Errors in communications sometimes resulted in too many Australians being sent to a particular front line trench which was already overcrowded. Radio communication did not exist and signal flags could not be used in a place such as that which Silas has drawn, so he had to run his messages, a desperate endeavour.

enfilading: Firing along the line of an enemy's trench, a particular form of flanking fire and a deadly one.

communication trench: One which runs from rear to front, linking the fighting trenches.

Lieutenant R. Harwood: Born in 1878, Harwood was from Fremantle. He became a lieutenant-colonel, was awarded the OSO and for a time commanded the 16th Battalion in France, 1917–18.

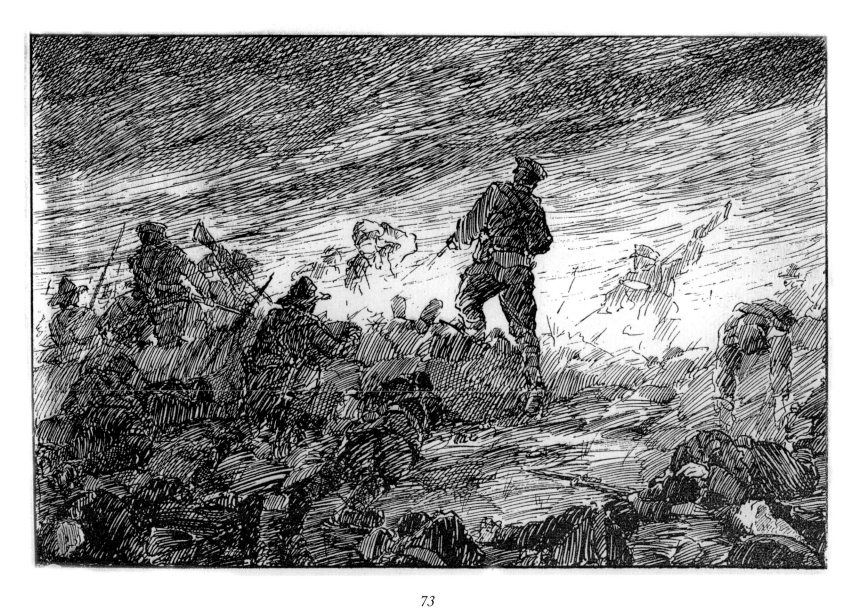

THIS is always a most heart-breaking incident. Name after name would be called; the reply—a deep silence, which could be felt, despite the noise of the incessant cracking of rifles and screaming of shrapnel. This was taken the morning after the charge, on Sunday night, May 9th. We, the 16th Battalion, were supposed to be resting, and were only to reinforce if the necessity arose. Unfortunately, through some error, we were sent into the firing line. At dawn, the following morning, there were few of us left to, answer our names when the roll was called— just a thin line of weary, ashen-faced men. The bodies on the right we were unable to bury for some days, as we were so hard pressed by the Turks.

Anzac, May, 1915.

Standing amid the corpses of many fallen, a company sergeant major or a platoon sergeant of the 16th Battalion calls the roll. The majority of his men are not present to answer their names. Ellis Silas later produced this scene in full colour, one of the finest paintings of the war. Silas wrote in his diary: "How heartbreaking is [as] name after name is called, the reply a deep silence which can be felt. Few of us are left to answer our names, just a thin line of weary, ashen-faced men, behind us a mass of silent forms, once our comrades. They have been there for some days, we have not the time to bury them."

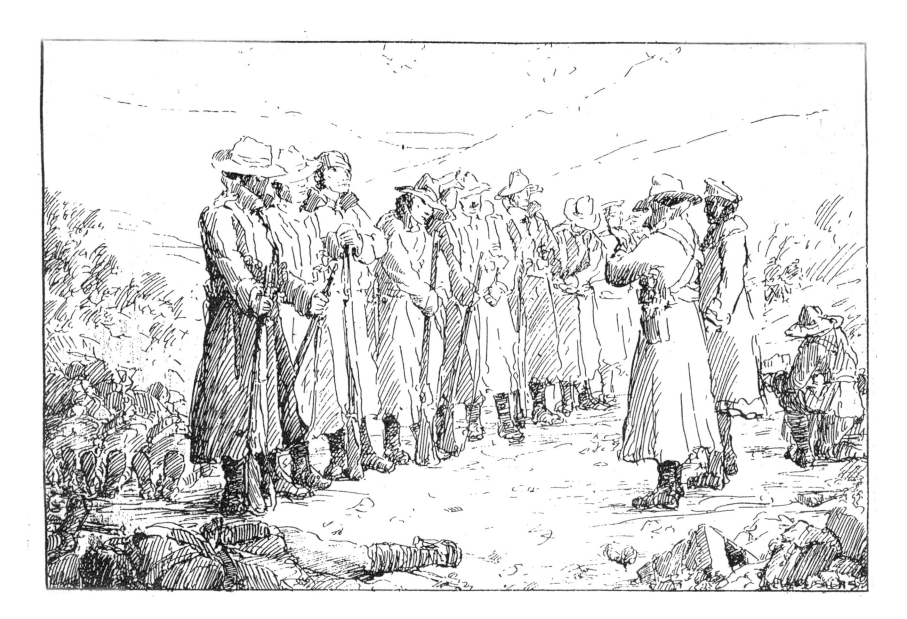

The Field Hospital.

HERE all that could be done to relieve the terrible sufferings of the worst cases, was accomplished under the most trying and difficult conditions. The operating table was made of packing cases. Occasionally shrapnel, would come flying through the tent. One unfortunate chap was hit three times in this manner, the last putting an end to his agony. Here, as everywhere else at Anzac, there lay those silent forms awaiting burial.

Anzac, May, 1915.

Even in the field hospital at the beach the wounded were in danger; not a single place at Anzac was safe from air-bursting shrapnel. Still, at a field hospital doctors had better equipment and they achieved miracles in saving lives. Some hospitals were staffed by Indian medical orderlies, like the one at right.

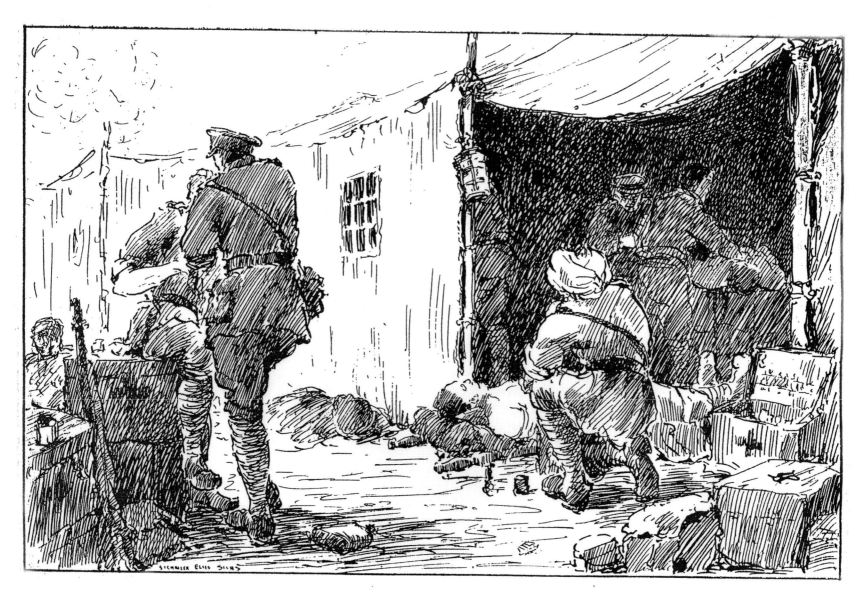

Near the Beach.

AFTER the incessant roar of the firing line, it seemed comparatively quiet at this spot. It was the end of a glorious afternoon. All the landscape was tinged with the warm glow of the sun. In the distance the blue ocean sparkled like a jewel. Up the narrow winding path, with its border of sad little mounds, placidly came the Indians with the ammunition mules. It seemed more like a scene in a play than one of the most tragic dramas in the world's history. But one was never left long in doubt as to the reality of it all. A buzzing, as of a huge bee—a flash of yellow flame—on the ground, a mangled heap, from which slowly trickles a dull red stream. Far away across the sapphire ocean, just a few more will be waiting in vain for the return of their loved ones.

Anzac, May, 1915.

The Indian soldiers and those of the Zion Mule Corps who took ammunition up the cliffs to the firing line were among the bravest men at Gallipoli. Many were killed by snipers or by bursting shells.

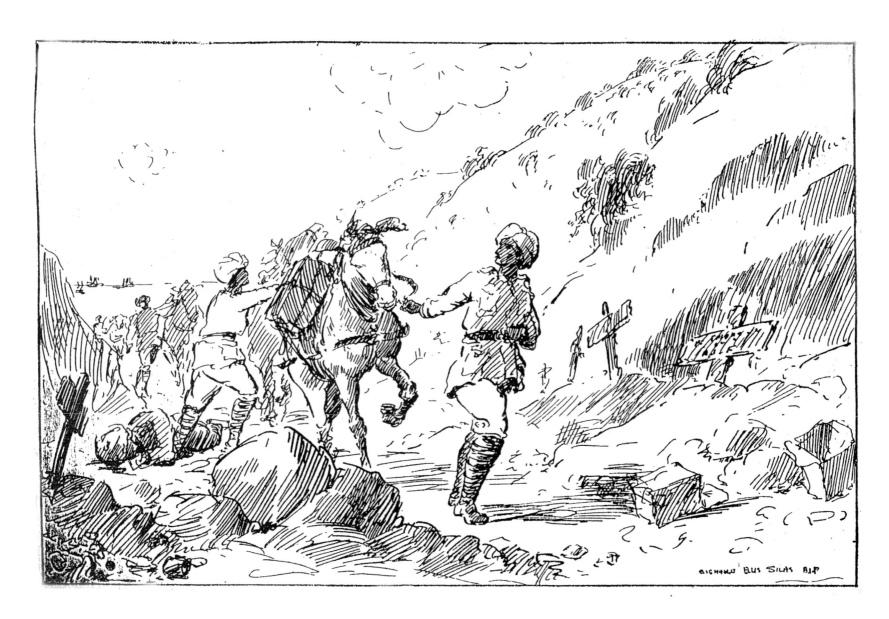

Boarding the Hospital Ship.

WE were towed from ship to ship. Always the same reply: "Full up!" Eventully we managed to get aboard one. The "cot cases" were hoisted on board by the derricks. Fortunately, on this particular day, there was a fairly smooth sea, so the embarkation was not difficult; but during the rough weather, the wounded suffered terribly when being put aboard the Hospital ship. Even right out here, a stray shell would occasionally come buzzing through the air. Note the narrow escape of the boatload alongside the ship. After having been in the thickest scrimmage, to be hit, so far out from the firing line, would have been truly annoying.

Gallipoli, May, 1915.

Casualties were sometimes so heavy, especially in April–May and again in August, that not enough ships and barges were available to transport the wounded to the hospitals on Lemnos, to Egypt and to Malta. The Army medical authorities had greatly under-estimated the number of likely casualties. Some men died before they could reach hospital and were buried at sea.

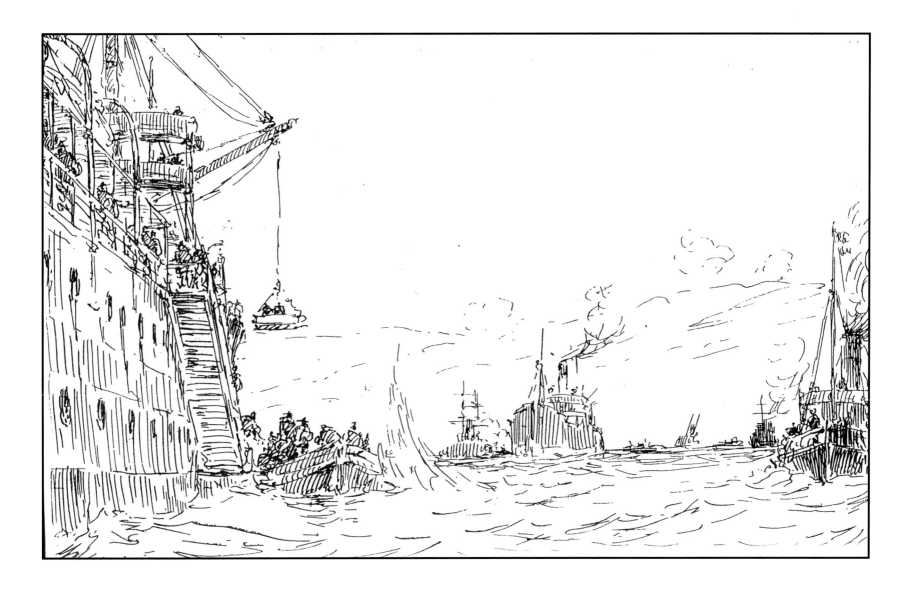

ON the ship there was only sufficient accommodation for 150, wounded; we had on board 500. Although delirious at night, I had the use of my limbs — so I did orderly work. Sometimes I would be on duty from 7 a.m. to 11 p.m., taking what little food I required when I got the opportunity. The medical officers were splendid. They worked night and day, scarcely giving themselves time for meals. On one occasion, Dr. Fiaschi, junr., worked for five hours on one case without a rest. The body on the left — covered with a blanket — was one of my cases; the poor fellow "went out" quite unexpectedly; he was not badly wounded. The man sitting on the right on the seat (a N.S.W. boy), though he had lost his right arm, was the merriest, brightest man on the ship.

Gallipoli, May, 1915.

Ellis Silas was himself very ill and exhausted but he made himself useful to the ship's medical staff, under Major A.G. Butler. A sensitive and humane man, Silas was as gentle with his sick and wounded mates as any nurse. Dr P. Fiaschi, of the First Light Horse Field Ambulance, became a colonel and was decorated with the Order of the British Empire.

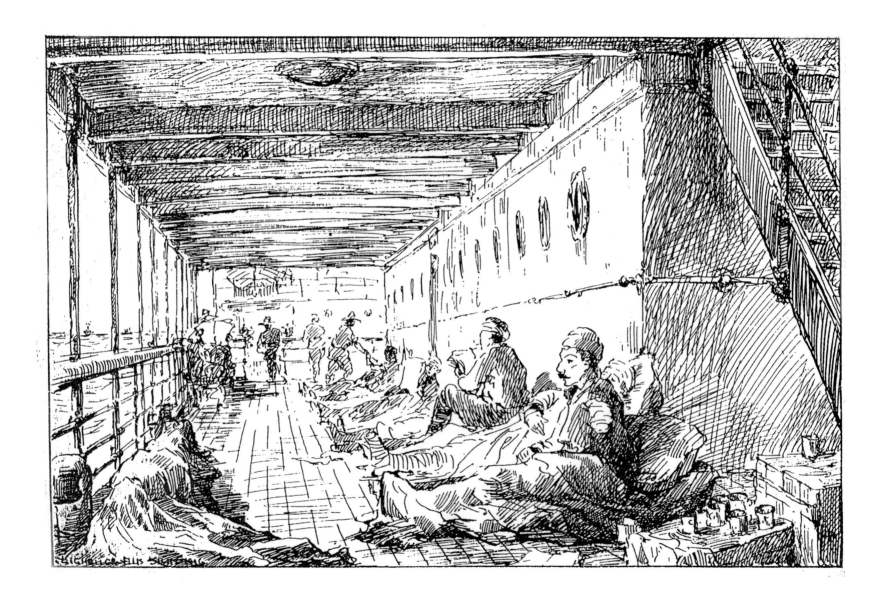

The Hospital Train.

ISHALL always remember the delightful feeling of peace; to be lying there amidst the sparkling cleanliness of this carriage in the Hospital train! Many of us were really too far gone to care much what happened; though, for my part, I was sufficiently conscious to appreciate my environment. The Indian orderlies had always a welcome smile for us, gave us cigarettes, and handed round tea and bread and butter. Think of it! — bread! One doesn't know what a luxury it is until one has been without it. For my part, I couldn't eat anything; to be in the train was all sufficient. In fact, once my duties on the Hospital ship were over, I just "went right under"; there was no longer need for further effort on my part.

Alexandria — Cairo, May, 1915.

Silas comments with pleasure on the cigarettes which the Indian medical orderlies liberally handed to their patients on the hospital train between Alexandria and Cairo. At the time, it was not known that cigarettes caused lung cancer and death.

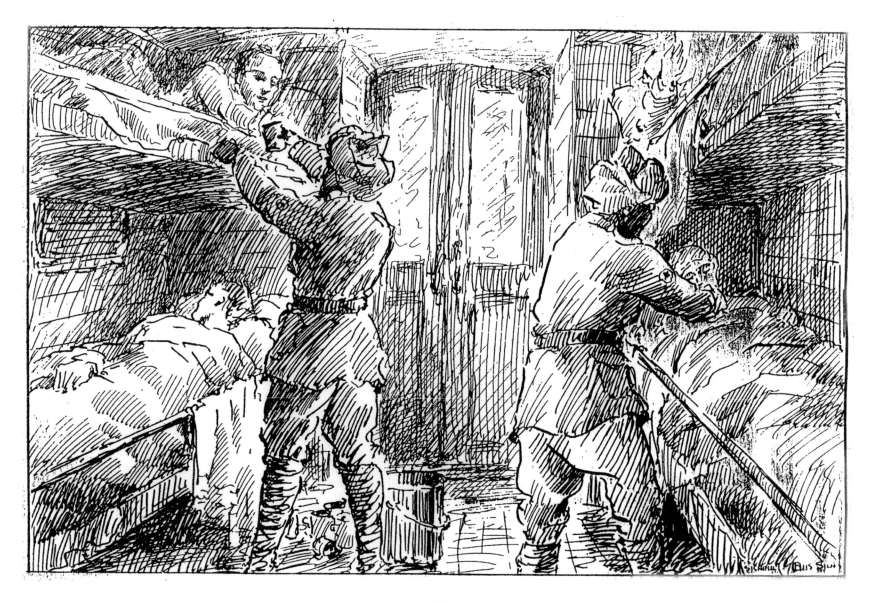

Palace Hospital, Heliopolis.

"Heaven!"

May, 1915.

An old royal palace in a suburb of Cairo had been turned into an army hospital and some wounded and ill Australians were lucky enough to be treated there in its cool depths. Ellis Silas needs only one word to describe this place — "Heaven!" After the hell of Anzac, the relief was indescribable.

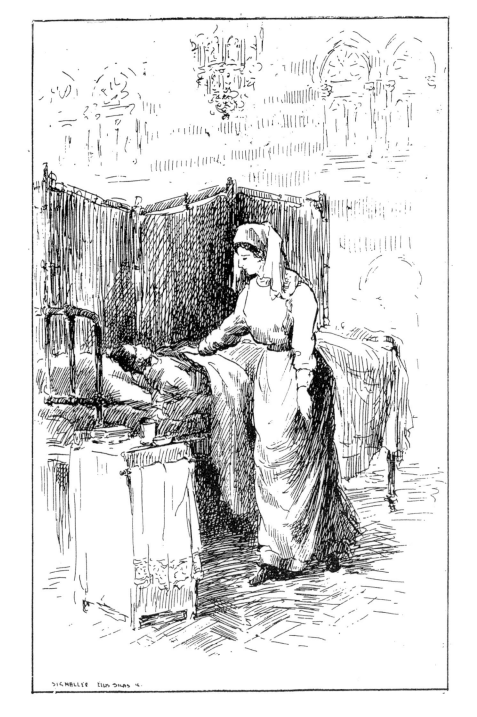

Fame.

Fame: – "These are Mine."

Gallipoli, December, 1915.

In December 1915 the Anzac campaign was over and by January all British Empire and French troops had been withdrawn. Silas considered that the Anzacs had won fame — which indeed they had. He shows the Angel of the Lord confronting the enemy Turks — represented by the figure wearing a Turkish tarboosh. She declares that the Australian and New Zealand soldiers, the Anzacs, who had fallen at Gallipoli were under her eternal protection and care. The drawing is appropriate for a holy crusade — which Silas believed that the Anzacs had fought against the hostile Muslim Turks. The Anzacs and their Allies had lost the fight and had retreated but they had won Heaven's approbation, in Silas' opinion.

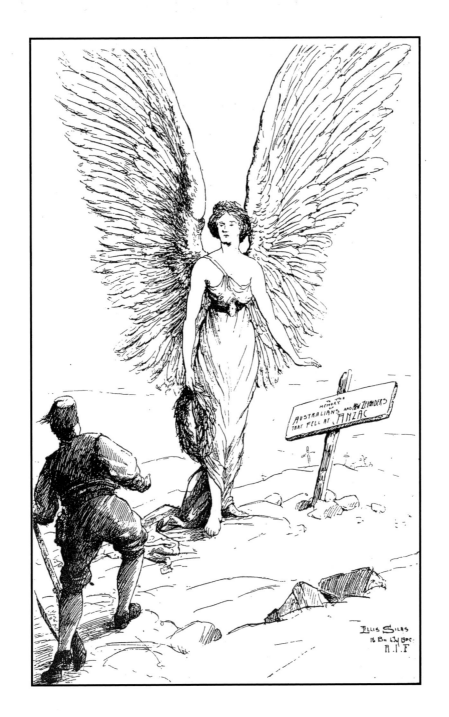

First published as *Crusading at Anzac* in London in 1916.
This edition published in 2010 by Rosenberg Publishing Pty Ltd.
PO Box 6125, Dural Delivery Centre NSW 2158
Phone: +61 2 9654 1502 Fax: +61 2 9654 1338
Email: rosenbergpub@smartchat.net.au
Web: www.rosenbergpub.com.au

National Library of Australia Cataloguing-in-Publication entry

Author: Silas, Ellis.
Title: An Eyewitness Account of Gallipoli /
Ellis Silas ; editor, John Laffin.
Edition: 2nd ed.

ISBN: 9781877058912 (hbk.)

Subjects: Silas, Ellis—Diaries.
World War, 1914–1918—Campaigns—Turkey—Gallipoli Peninsula—Pictorial works.
World War, 1914–1918—Art and the war.
World War, 1914–1918—Personal narratives, Australian.

Other Authors/Contributors:
Laffin, John, 1922–2000.

Dewey Number: 940.426

Printed in China by Everbest Printing Co Limited